RIDGES

ALSO BY
DIANE MARQUART MOORE

RIDGES

POEMS BY DIANE MARQUART MOORE

PAINTINGS BY DON THORNTON

PINYON PUBLISHING
Montrose, Colorado

Paintings used with permission by Suzi Thornton.
All paintings are 12" x 9" except for *Cheniere Don* and *Isle Dernieres,* which are 7" x 5".
Acrylic on canvas.

Photograph of Victoria I. Sullivan and Diane M. Moore, On Their Way to Cheniere au Tigre, by Jo Ann Lordahl.

Photograph of Don Thornton by Suzi Thornton.

First Edition: May 2021

Pinyon Publishing
23847 V66 Trail, Montrose, CO 81403
www.pinyon-publishing.com

Library of Congress Control Number: 2021931637
ISBN: 978-1-936671-74-8

ACKNOWLEDGMENTS

I am deeply grateful to Suzi Thornton of New Iberia, Louisiana for gifts and loans of Don Thornton's paintings for *Ridges*; and for 35 years of encouragement of my writing, as well as for her friendship during those years;

I appreciate the constant friendship and support of Darrell Bourque, my "writerly" mentor and master poet, and for the friendship and support of his wife, Karen Bourque, who has supplied me with glass work that has become photographs for covers of many of my books;

I thank Susan Entsminger, the superb editor/publisher of Pinyon Publishing, who "saw the landscape through the man and the man through the landscape" and published *Ridges*;

And to Dr. Victoria I. Sullivan for technical and emotional support of my work throughout 42 years. My work would still be in cardboard boxes were it not for her interest and assistance;

I am also grateful for my sacred spaces in New Iberia, Louisiana and Sewanee, Tennessee where I can work at my craft without interruption;

And for the gift of 85 years in which I have had time to pursue this vocation.

For Don and Suzi

CONTENTS

FOREWORD

In *Ridges* the poet Diane Moore takes a man's fierce love of place and word and line and color and creature and creates a reliquary of sorts for ekphrasis, elegy, memoir, and eulogy. She takes us to that borderland where liminality lends itself to various languages to honor the life and work of painter, teacher, and poet Don Thornton.

In this place gulls talk and pelicans can sing if they are called to sing and mud flats are alive with being, and a man painting the landscape and parsing biology and poetry and ecology and music becomes an extension of the landscape he so loves and so tenaciously holds on to for both meaning and sustenance.

I am reminded in these tribute poems of W. H. Auden's opening lines in his "Musée des Beaux Arts":

> *About suffering they were never wrong,*
> *The old Masters: how well they understood*
> *Its human position: how it takes place*
> *While someone else is eating or opening a*
> *window or just walking dully along …*

Moore's tribute to Don Thornton reminds us as well that nearly always there is a great divide in the world where art is created and where the artist suffers creation itself.

Each of these poems in *Ridges* is keyed to one of Thornton's paintings of the chenieres he was drawn to. It is the cheniere itself that fascinated him. There are references in Thornton's own poems to the creatures and to the rhythms and patterns of that specific place, but the artwork is exclusively of place. His paintings are the work of an environmentalist, an ecologist, and a botanist philosopher. Repetition and return are the informants of love of place here. He leaves all else for the poems he will write and for the teaching he will go to on his return from the ridges and for future poets like Moore to sing of in her own poems.

The reader sees how each poem is informed by Thornton's selected painting. There are the blue blue skies, the rosy sands in the mud flats, the yellow he assigned to love, the brooding skies too, the impending storms, the golden, fuchsia, lavender and purple sunsets, each detail a

springboard for Moore to attach to a life, a marriage, a vocation, the sacred, the obstinate, the tortured, the mendicant, the explorer.

But this set of poems goes beyond being a response to a set of paintings about a place a man loved. The poems are elegiac in tone and delivery. They honor the passing of one who mattered, of one who saw as others did not, of one who came back again and again to what his life and his life's work might mean. It apparently was not an easy life, but it was a life clearly dedicated to service and the poems record service of the highest order. Moore's poems open windows on how precise and dogged Thornton could be about teaching, about the spiritual life, about this in-the-world-being, about how to live with the other creatures of the world, about suffering itself.

When we read the poems as memoir, we know that memory plays with fact and detail. The poems here are what a poet admirer is remembering and maybe that is the best take on a life: a take allowing the variances and vagaries of memory to paint as true a picture of a life as can be painted. Surely there are people who knew other Don Thorntons than the one contained in this set of elegant tributes to the ragged, rugged, burnished life presented here, but that does not lessen the truths in the poems. This is not exclusively Suzi's Don Thornton, or his colleagues', or his students'. Each knew him in ways different from the poet, but the man in these poems is moved beyond the familial, beyond the mundane, beyond personal.

These poems take an artist-poet-teacher to the crossroads of being, that sacred ridged place where he lived most profoundly, most honestly, most deeply. It was a place that he took the husband, the lover, the teacher, the poet, and the walker in remote places to sketch out his relationship to the land and to the creatures in it. It is in that place that Diane Moore goes with him to be able to write this one account of his life.

—Darrell Bourque
Louisiana Poet Laureate,
2007-2011
May 26, 2020

Look deep into nature,
and then you will understand everything better.

—Albert Einstein

Chenieres

The term cheniere derives from the Cajun word *chene* for oak. The Mississippi Chenier Plain is an ecological feature composed of coastal ridges 12-18 miles wide and 6-20 feet in elevation. These live oak-dominated ridges stretch 124 miles from Sabine Pass, Texas to Southwest Point, Louisiana. The Chenier Plain is a rich mixture of wetlands, uplands, and open water that developed 7000 to 3000 years BP (before the present) when sea levels stood 16-20 feet lower than at present. Sea level rise between 3000 and 2500 BP submerged the chenieres to the extent we see them today.

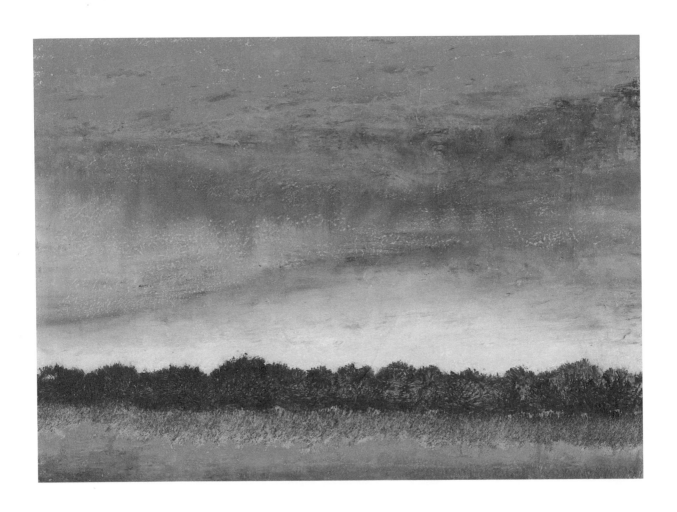

CHENIERE DON

He intended to show us the shiners
that bordered his fishing camp at Dulac
when mosquitoes had died out
but he fell ill
and died before the trip,
leaving behind mindscapes

rendered over and over.
The painting of dark clouds
hovering over a cheniere
not too far from Last Island,
his anger expressed
at a world in which he felt alone.

He built a bomb shelter,
a rude dome in his backyard
and a concrete wall in the front yard,
spoke of ruined brushes and suicide,
a man contradictorily an isolationist
and a teacher of gifted children.

He was passionate, regarded his art
as temporary manifestations.
Not known for ambiguity or soft words
he clung to visions of gulls
wheeling in outer limits,
short strokes of oaks marking his last days,

"banking divine rhythms as sacred patterns"
yet sleeping with a pistol under his pillow,
disaster hovering in blue skies or black clouds alike.
but always the heaps of gastropods
creating sharp ridges in his mind,
the wonder that he moved to small canvases.

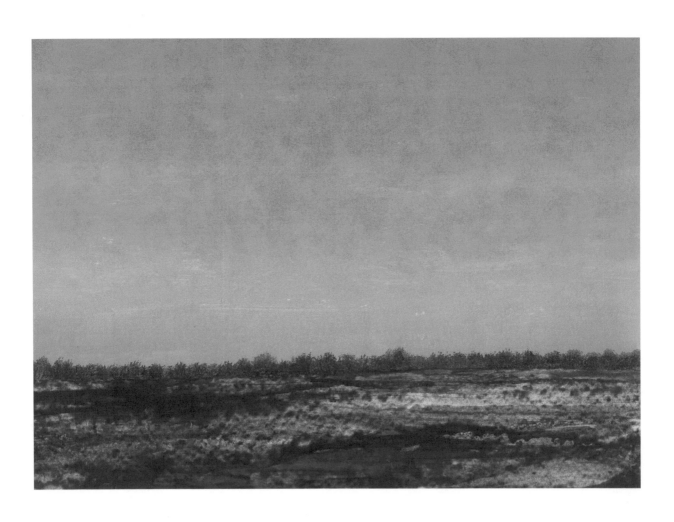

SUZI

Chenieres, beach ridges on plains
jutted above mud flats,
hundreds of renderings
he painted before he died
and after he passed
she kept him close,
the paintings in a box beneath her bed.

His spirit returned an improvement
over what he had been to her.
She remembered how he had found her
at 18, swinging from the limb of an oak
singing rhyming poems that became
her book, *Sometimes Childhood Stinks*,
an eternal tomboy who made him laugh.

She was always out on a limb
recycling, eroding coastlines her platforms,
his platforms—just causes aligned.
At his death she placed
one of his sculptures in City Park
delinquent children quickly destroyed
but she held back her anger,

gathered up the broken bones in her arms
and planted a lemon tree in the backyard
that faced offenders in the park,
an ode to his art and their marriage,
the tart fruitage of his spirit
now a deeper yellow with the thick skin
she had possessed throughout.

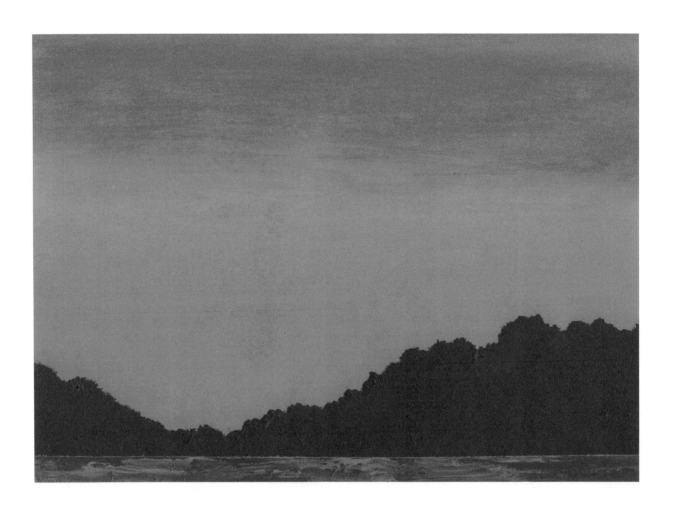

10

BEFORE WE KNEW HIM

(CHENIERE AU TIGRE, 1977)

We found abundant sediment and *chêne*,
woods thick with hackberry,
honey locust and holly,
the ghost of a shipwrecked boy
abandoned on a ridge.

The boy had been devoured by a starving tiger
and they built a resort in his shadow;
Lafitte and his band
hid their gold under *chêne*,
two hurricanes swept the legends away.

But when you held my hand
to cross a stile that day
and we stepped onto banks
of wooly rose mallows, morning glories,
wild grape at Hell Hole Bayou,

my heart raced wildly
in synchronicity with yours,
humidity clung to our faces
startled by the forbidden,
the sky blazing with beginning ...

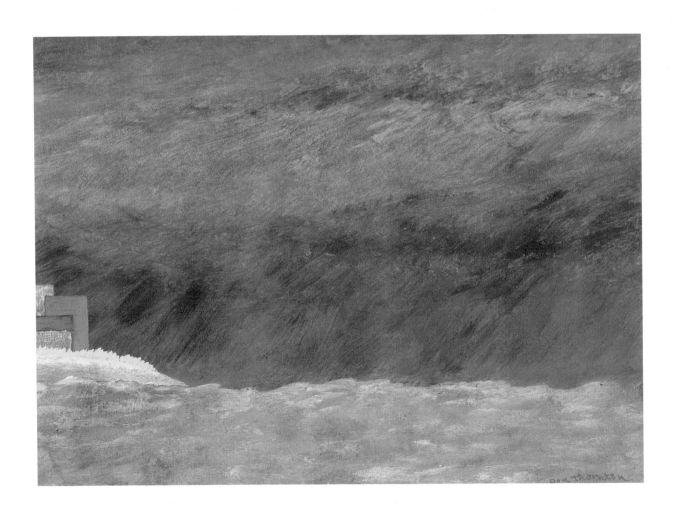

BURIAL

Trapped in the mausoleum
we shudder at faint whiffs of carcasses,
think about the discourtesy
of life interrupted, art returning
to the shell life of old ridges he saw,
painting them more than once.

A mosquito tunes in
with the sting of life ended
as we stand among smells
emanating from the dead in drawers,
flee the Prayers of Committal—
the scent of decay and sacrilege.

She could not bear to bury him
in one of those drawers
a corpse of powerful disobedience
rowing toward the netherworld
as if no distance lay between tree
and swamp and never going away,

no longer troubled
by what he saw on chenieres
beyond their many selves,
what he painted of all nature's forces
by the glaring light on summer waters …
the earth now taking him back.

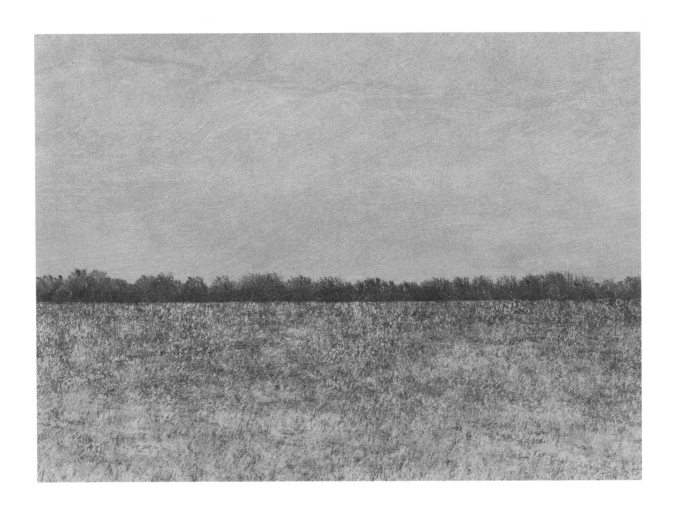

14

OVER AND OVER

Why do you paint the same thing
over and over? they ask
and do they know nothing
about the life of anything
unless they live it over and over,
paint it, write it, play it
even with broken spirit,
celebrating old awakenings.
He collected the same specimens
of leaf and insect,
shell and fallen bird over and over.

Like the music of Philip Glass's
Itaipú performed as a sacred chant
with continuous fervor,
he reached for indestructibility,
painting until the color of switchgrass faded,
the oaks burned, old marshes
dried up, green turning to brown,
his vision seeking to bring them back
as he walked on water,
found perfection without urgency …
immortal.

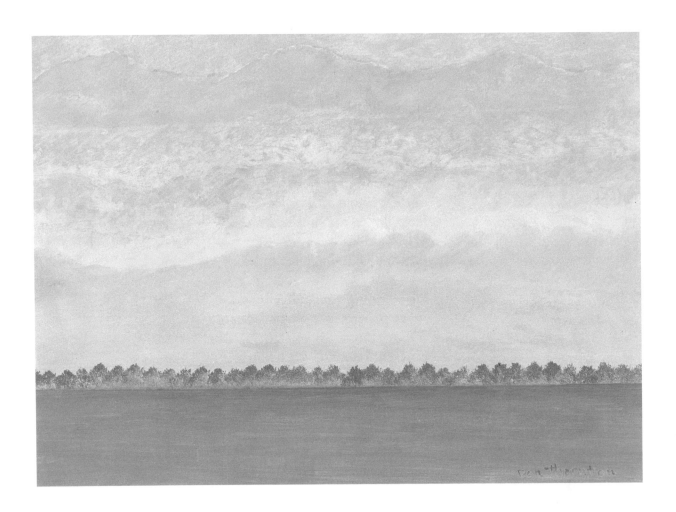

BLUE SKIES

That blue sky so close to the water,
a mirage of ridges behind,
was clear enough to banish bad spirits;
he could hear Ella Fitzgerald …
no, it was Willie Nelson …
singing "Blue Skies" that day.

The scattered frequency
moved his eyes into calmer light,
thoughts cleared of apparitions,
the mud flats of old sufferings,
and the wind, a mouth for Spirit,
created verse void of form within.

Oaks on the ridge swayed
while he drifted in the boat,
soon fell asleep
in the color of blue,
awakened to music dissolving,
his soul spinning on a tuning fork.

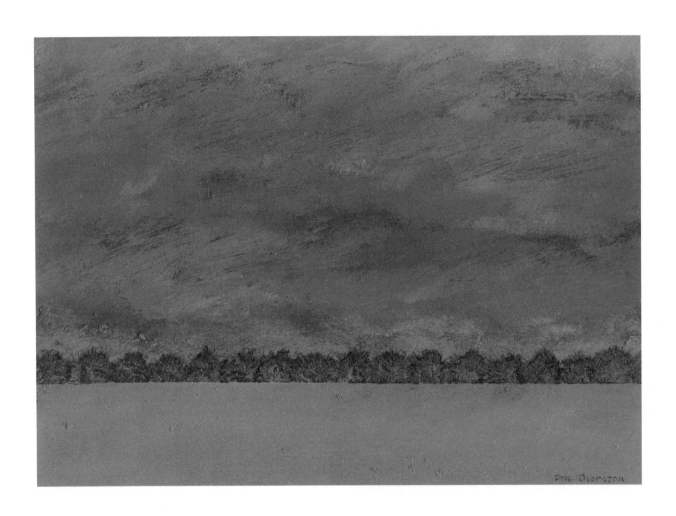

18

HURRICANE ON CHENIERE CAMINADA
OCTOBER, 1893

It was a peaceful fishing village,
Chinese, French and Italian living side by side,
and some of the old ones like Mr. Gaspard
knew the sky's predictions, watched
the sea of gray clouds following a cold front;
Man-o-war birds, seagulls, pelicans

deserting the Gulf … cows and horses
rushed onto the ridges wailing.
No telephones, telegraphs, television,
only old men looking at the gray sky
and speaking of drownings—a total inundation,
human screams riding the waves.

Gold coins the people had hidden
shone beside dead bodies on sandy beaches,
three small sisters died holding hands,
their bodies thrown against a barbed wire fence,
buried holding hands among 2,000 who perished …
the sky never that gray again.

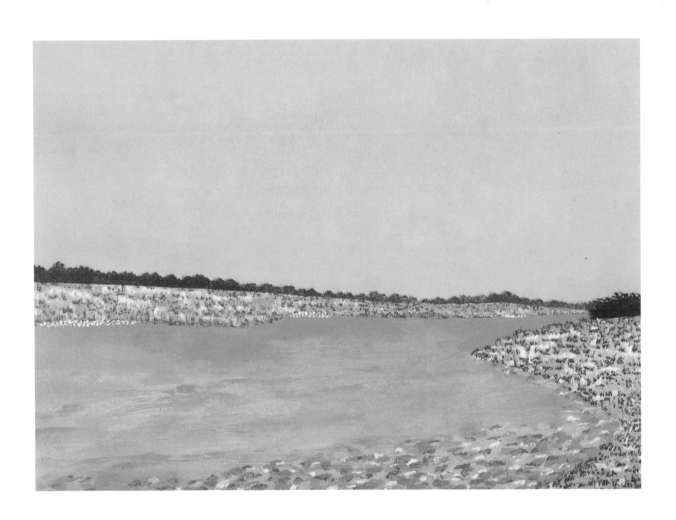

THE ANIMALS

Above and below surface
he loved their variance,
that old sea saucer, a bug-eyed frog,
brown pelicans flying and diving,

gulls squawking overhead;
the eyes of hungry wolves on the ridge …
He shared this life with them,
yet he pined for alligator gumbo,

a plate of speckled trout or flounder
and when he saw a turtle dropping eggs
in warm sand, he felt outrage with himself
for consuming creatures of the water

or any of those crawling the silent beach.
He charted and mapped their wings and eyes,
feathers and scales in his mind,
holy images without intaglio.

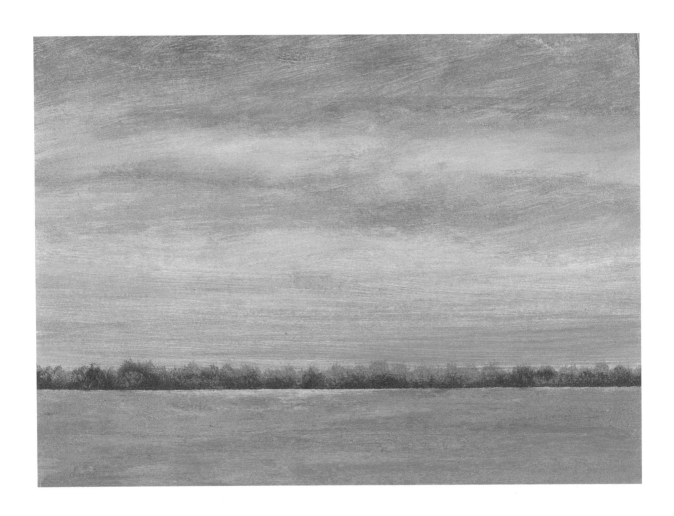

SUNSET

Doctors spoke of older humans
suffering something called "sundowners,"
he knew sunset marked beginnings of new cycles.

In blushing light Hesperus moves in
as color fades out;
night goddesses appear in murky water.

On the beach coons, skunks, armadillos,
emerge. A nighthawk circles his hiding place
while mosquitoes needle his skin

carrying malaria, the greatest killer of all time
before *cinchona*, but no trees like that
grew on his beloved chenieres.

He would risk the dread disease
to see the nighthawk
ascend above the star of night life—

an armadillo, "hairy little tank with ears,"
to hear the night shattered by a screeching owl
and a foghorn announcing distant futures.

At dawn, having made their tribute,
angels folded their wings, and he arose,
eager to squeeze out a tube of ochre.

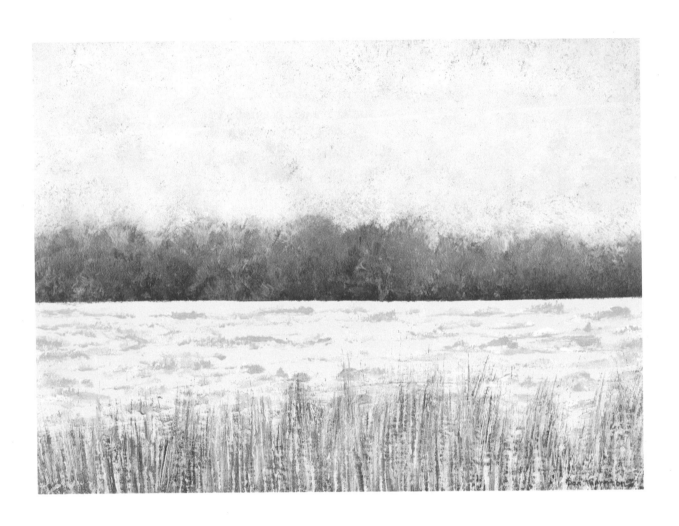

24

STEWARD

The Roseau Cane is green now
and how long will that last?
The mealy bug of China
buries deep between leaves and stalk,
feasts on the world's largest stand,

cane beginning to turn brown.
No more duck blinds,
thatched roofs, and sturdy brooms;
and would the red-winged blackbird
no longer make its home there?

Could it be planted elsewhere?
He splashes green in wide strokes
making it hearty and free,
an escapee from the invader,
wondering if he is the sole coastal steward.

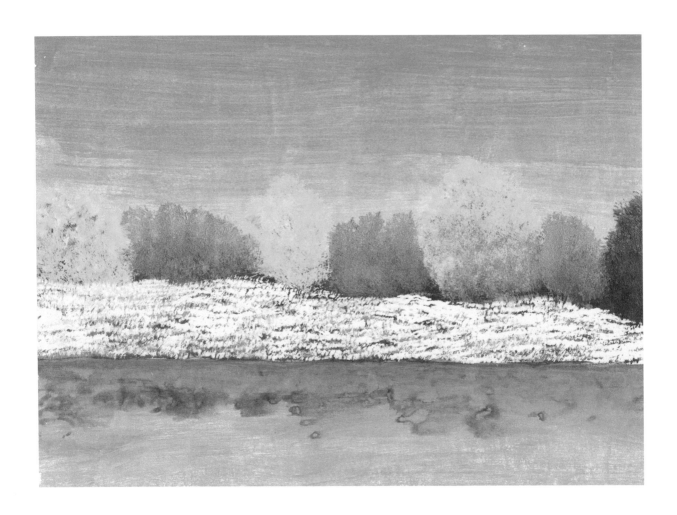

26

THE COLOR OF WOMEN

When he was younger
he thought love wore a yellow dress,
women, a vast field of yellow poppies,
visions without subtlety,
bright candles and early morning light,

a heat hotter than the sun
so many likenesses of one color,
beings he looked for
and who did not look for him.
It was an old story

fire becoming ash,
his avoidance of surrender,
the sun setting, the moon rising,
what he called a pot of yellow
wearing a woman's dress.

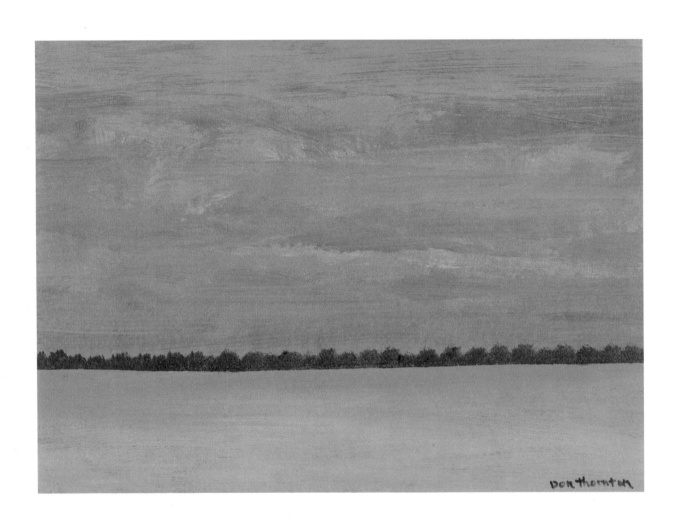

28

WHEN THE SKY TURNED PURPLE

he thought of the feminine energy
of Maleficent in *Sleeping Beauty,*
of spring beauties, wild violets
growing in the swamp, how powerful
purple's draw to eternal beauty.

He would build a house on the ocean
even knowing all to be external sight,
purple a magic without body,
the cloak of God hovering over him,
weather watchers of warblers

singing to peewees hidden in the thickets,
the chenieres their hotels when they migrated,
80,000 birds feeding on thorny plants.
He pretended indifference so he could sleep,
take his boat out at a purple dawn.

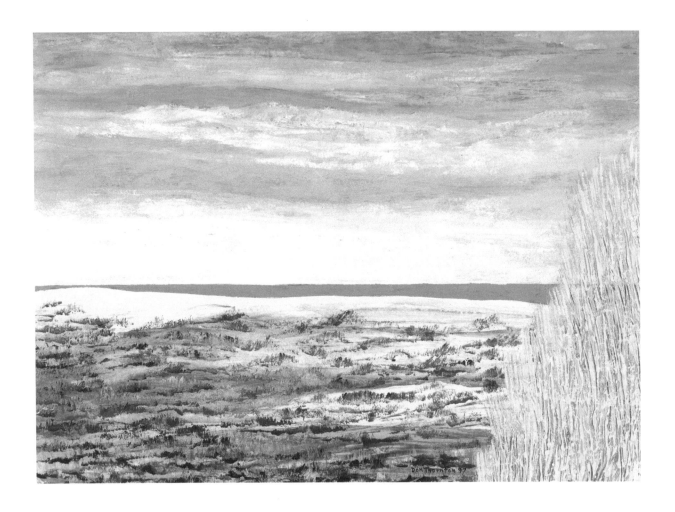

MUD FLATS

Submerged and revived twice daily
the tidal flats begged for no intrusion.
He did not disturb the nests of gulls
and terns, the flats always moving,
widening, thinning,

submarine sand bars,
home to foxes, mink,
crabs, fish, oysters …
He thought of them as agricultural
paradise but shooed away hikers,

developers, dredgers, hunters …
It was his private kingdom,
an expanse of sand and mud,
the estuarine habitat for wading shorebirds—
gulls, terns, the pelicans he called

"tired old Shriners waiting out God"
and in the Gulf nearby, the surprise
of a porpoise. He feared the flats
would become a desert
even with him painting them every day,

the flats themselves
restless from continual harvesting
the Gulf itself a threat of hurricane,
talk of coastal barriers eroding,
estuaries behind them disappearing …

31

Don Thornton 97

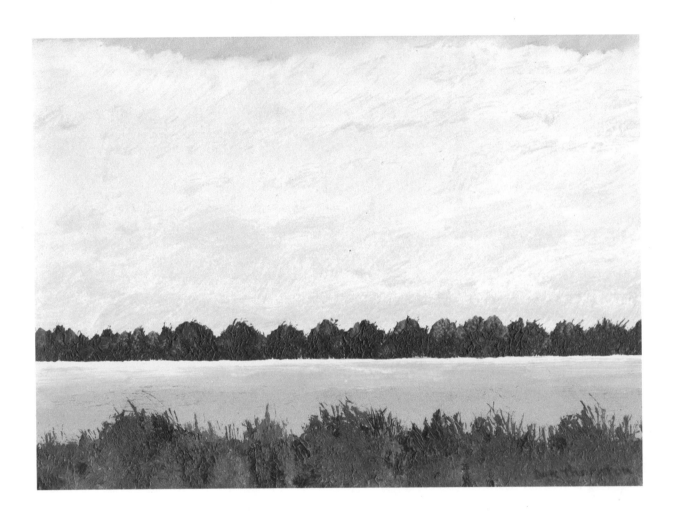

ANOTHER ICONOCLAST

Suzi told him about Walter Anderson
who rowed out to Horn Island, Mississippi,
drew and painted animals—
a blue crab crawling on his landscapes,
also living within the sound of waves;

but Don was born
in a shack on ruined earth,
painted ridges and mud flats
he refused to fill
with creaturely life.

Anderson lost his mind,
painted island life that filled a museum.
He reminded Don of his misfortune
being born in a shack on ruined earth
but he kept painting the empty ridges

and long mud flats,
scenes he refused to fill with creatures,
thought of angels singing,
dancing on waves
exultant as migrating birds

not staying in the nests
they had created, leaving behind
salt on the waves.

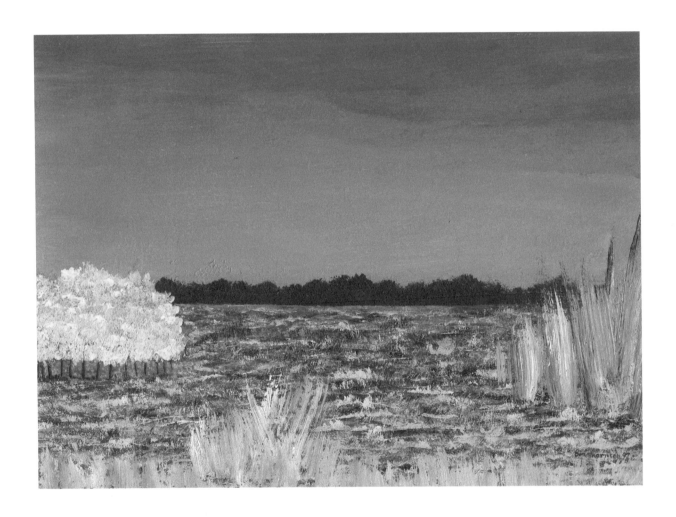

34

THE STUDENTS

When the elements spoke to him
he wanted to take his students
onto the ridges or into the swamps,
thousands of them he had taught,
for whom he had been wake-up call,

painted as orange hues of the Spirit.
He wanted them to feel
the vibration of waves,
earth, air, fire, each small unit of energy
in nature, although she told him

he wrote biology instead of poetry,
that he taught likewise,
and he answered her
biology was poetry,
the creator also dabbled in blue fire,

trees and rabbits had souls.
He envisioned himself a mangrove tree
standing on stilts his students looked up to,
for whom they wrote poetry,
shared their virtuous dreams.

He carted their dreams with him,
focusing his inner eye
but never took the youth onto the ridges,
brought home to them a box of feathers,
wings of bitterns he had disturbed.

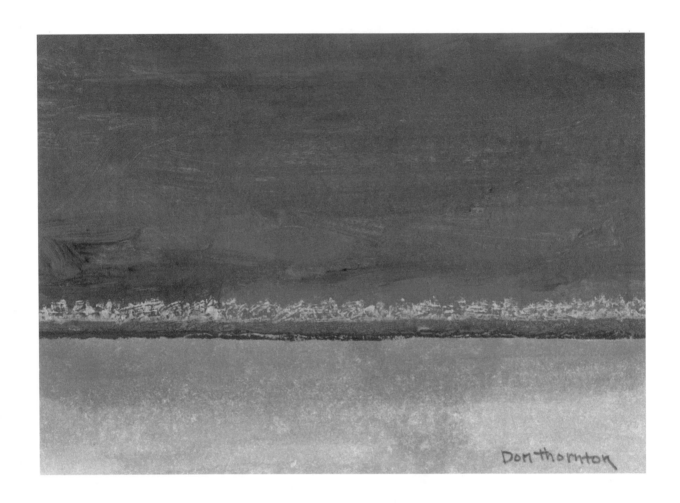

ISLES DERNIERES AND THE HURRICANE OF 1856

He felt the Island's shadow had substance,
once a place as continuous as his own art,
it remained the last piece of land between mainland
and the Gulf, presented some lesson
from which he could learn—

intimations of what it would be like
to be blown away under an arching sky,
plants unable to hold, blinding salt spray
closing the eyes of a final look;
a resort village five feet above the sea

flattened by air too alive
over 100 people lost,
now sand and driftwood—
a fishing paradise still alive with
redfish, drum, flounder,

porpoises leaping in the sea.
In 1856 only a few allowed to keep going
when everything dropped away
because rich planters danced with belles
from Terrebonne parish while surf rose,

large swells coming off the Gulf,
planters, sea bathers, beachcombers
swept away by a tempest
clutching timbers, rain and Gulf mixed,
dark clouds of nostalgia and loss.

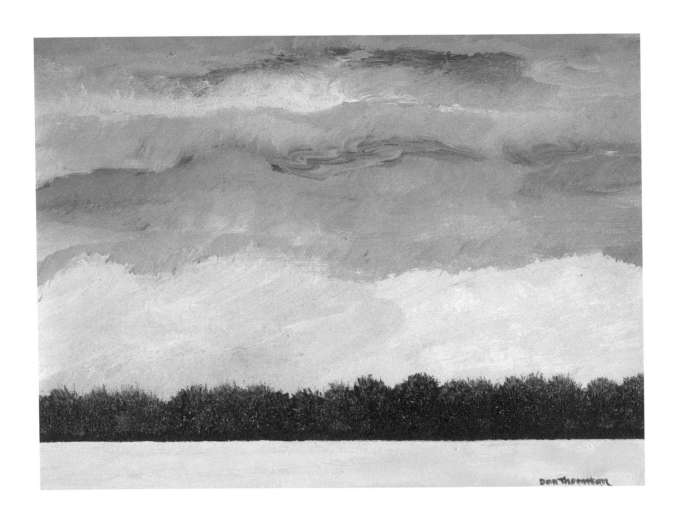

38

GHOSTS

In the night ghosts walked on old ridges,
early inhabitants, the Chitimacha Indians
who had perished on their claim
that Caminada was "The Isle of Chitimacha";
they were accompanied by Italians, French, Chinese …

a polyglot of law-abiding and lawless,
the pirates Lafitte and Gambi
among other specters lost in hurricanes.
By day, all returned to blue skies,
calm waters … in darkness some ghosts laid claim

to the title of "Sisters of the Cheniere"
and to an old bell, never shiny
or finely cast that had done its job.
In the wake of hurricanes
still tolled prescience of death.

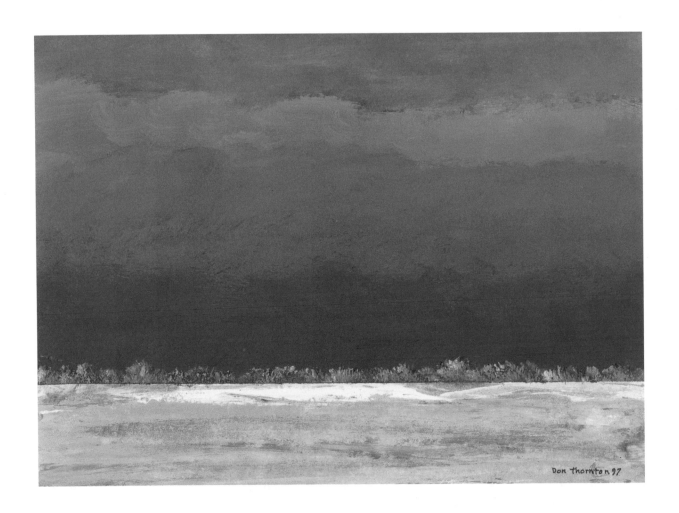

40

JOB

One afternoon as he lay on the beach
he could feel a storm brewing,
saw birds taking flight, the sky graying.
He had come to repent in dust and ashes
because the doctors had their own form
of a bell tolling.

There were still things beyond him
he did not know,
and when an unfriendly wind
dipped down and almost hurled him
into the Gulf, he thought of Job,
of suffering and God demonstrating

the order of the universe,
speaking to him out of the whirlwind,
asking him where he had been
when he laid the foundations of earth
when he had plainly told him
that order was the heart of wisdom.

God spoke to him
in the heart of the wind,
a series of "where were yous?"
the omniscient voice of justice
thundering over the ridge,
telling him he had not been a righteous man;

there was no external reward,
only a whirlwind that had inspired Milton and Jung,
one that sent him scurrying to his boat,
the foaming waves propelling him home;
where he painted the cheniere again …
then Job, his red hair billowing wildly.

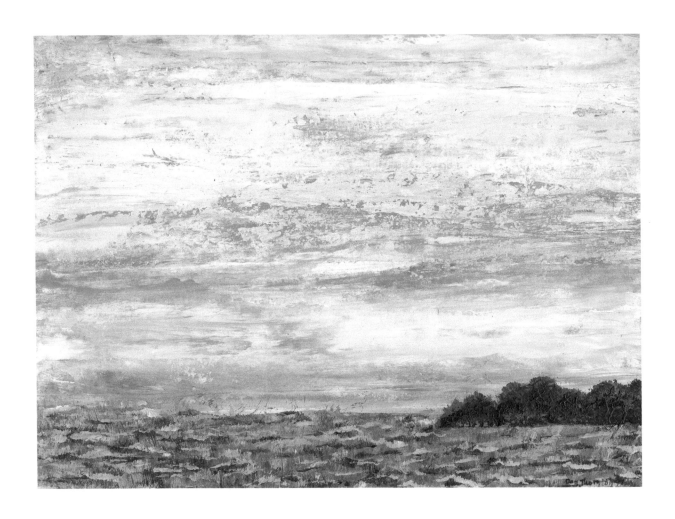

FAIR SKIES

Rose-colored streaks hung over
the fragile front lines of the coast—
the continuous energy of a pulsating ocean
driving plovers, raptors, roseate spoonbills
into shrub dotted dunes.

He had bonded with killdeer, otters and possums,
lived in a place where he could hear dew fall,
risked his life with black widows and mosquitoes,
become King of the Ridges who teased One
he called "a cruel wizard."

He entered death without losing anything,
trusting he had helped keep things in place,
the seagrass and shellfish beds,
harnessing first editions of wildlife,
holding back the building of beach structures

and leaving behind the paintings—
images of coastal life—
a legacy of protection for the last lands
before the water, the barriers intercepting
surges of wicked winds—he hoped—

NOTES

1. In "Cheniere Don," the line "banking divine rhythms as sacred patterns" comes from Don Thornton's poem, "Sunrise," in his book, *A Walk on Water*.

2. In "Suzi," the line "*Sometimes Childhood Stinks*" references the title of a book of verse by Suzi Thornton.

3. In "Sunset," the line "hairy little tank with ears," comes from Don Thornton's poem, "Armadillo," in his book, *A Walk on Water*.

4. In "Mud Flats," the line "tired old Shriners waiting out God" comes from Don Thornton's poem, "Pelican," in his book, *Sounding*.

5. In "Another Iconoclast," the reminiscence of "a third poetry sometimes never written" is inscribed on the print of a mural, on the wall of a cabin owned by Mississippi artist, Walter Anderson.

6. In "Fair Skies," the line "a cruel wizard," comes from Don Thornton's poem, "Mending," from his book, *Mentor*.

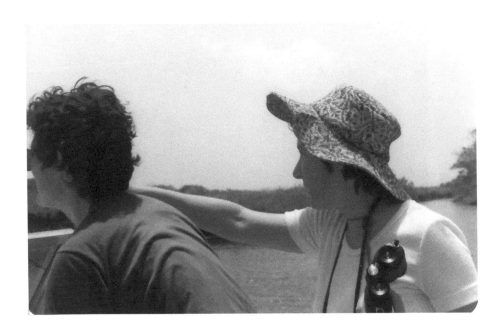

Victoria I. Sullivan and Diane M. Moore

BIOGRAPHIES

Diane Marquart Moore is a poet, journalist, book author, and regular blogger at *A Word's Worth*, who divides her time between Sewanee, Tennessee and New Iberia, Louisiana. She is a regular contributor to the *Pinyon Review*, a journal of Pinyon Publishing in Montrose, Colorado, has published in *The Southwestern Review at the University of Louisiana, Lafayette, Louisiana, Interdisciplinary Humanities, Xavier Review, Acadiana Profile Magazine, American Weave, Louisiana Historical Review, Trace*, and other literary journals. She has been an associate editor for *Acadiana Lifestyle Magazine*, New Iberia, Louisiana, feature writer and columnist for *The Daily Iberian*, New Iberia, Louisiana, as well as a feature writer and book reviewer for *The Yaddasht Haftegy* in Ahwaz, Iran where she lived during the reign of the Shahanshah. Her young adult book, *Martin's Quest*, was a finalist in the Heekins Foundation Award Contest and was selected to be on the supplementary reading list for gifted and talented students by the Louisiana Library Association. Heron Press received a grant from the Gheens Foundation of Louisiana to provide *Martin's Quest* as a supplementary text for middle-grade and high school students in Lafourche and Terrebonne parishes during the book's publication year. Moore has written 928 posts and received 278,060 page views on her blog, *A Word's Worth*. She is a retired archdeacon of the Episcopal Diocese of Western Louisiana.

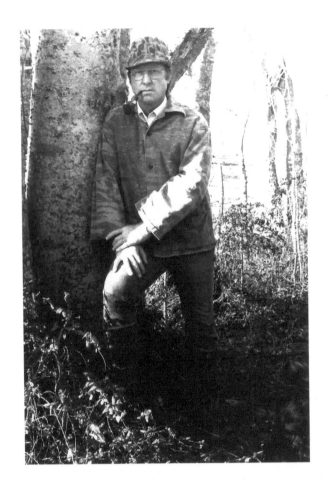

Don Thornton

Don Thornton, painter, poet, sculptor, and teacher, painted pictures of the chenieres for thirty years when he visited his fishing camp near Dulac, Louisiana. He was born in Winnsboro, Louisiana, where he wrote that "he was immersed in and surrounded by nature and the delicate equilibrium of violence and tranquility in the woods." Don graduated from Louisiana Polytechnic Institute in Ruston, Louisiana, worked as a roughneck on an oil rig in the Gulf of Mexico, taught high school in Vivian, Louisiana and returned to college where he received an M.A. from Louisiana State University in Baton Rouge, Louisiana. He served as Artist in Residence at the College of the Mainland in Texas. While living in Texas and as editor of *Texas Portfolio*, Don produced a book of poetry entitled *Sounding*. From 1967-1973, Don taught Drawing and Architectural Drawing at the University of Louisiana at Lafayette. In 1985, Don published a book of poetry entitled *A Walk on Water* in which he wrote that the poems "expressed the concept of man bonding with the earth and was an act of faith in aesthetics, ecology, and the preservation of the planet Earth." He taught gifted children in St. Martin Parish in south Louisiana and offered them an opportunity to be producers of literature, not just consumers, so that language became part of their creative lives. He edited, published, and distributed many student anthologies containing their creative writings and art. His own haiku poetry has appeared in the Japanese Museum of Haiku in Tokyo. Don's paintings have appeared in one-man exhibits throughout the U.S., including the Houston Contemporary Art Museum, and he once designed sets for the Houston Ballet Company. He died of cancer in 2002, shortly after he held a one-man show of paintings about the Biblical figure, Job.

CPSIA information can be obtained
at www.ICGtesting.com
Printed in the USA
LVHW071308130421
684248LV00032B/1